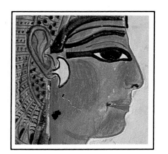

GREAT WORKS OF
EGYPTIAN ART

Elizabeth Longley

A Compilation of Works from the
BRIDGEMAN ART LIBRARY

SMITHMARK

Great Works of Egyptian Art

This edition published in 1996 by SMITHMARK
Publishers, a division of U.S. Media Holdings, Inc.,
16 East 32nd Street, New York, NY 10016.
SMITHMARK books are available for bulk
purchase for sales promotion and premium use.
For details write or call the manager of special
sales, SMITHMARK Publishers, 16 East 32nd
Street, New York, NY 10016; (212) 532-6600
First published in Great Britain in 1996 by
Parragon Books Limited
Units 13-17, Avonbridge Industrial Estate
Atlantic Road, Avonmouth, Bristol BS11 9QD
United Kingdom

ISBN 0-7651-9893-2

Printed in Italy

Editors:	Barbara Horn, Alexa Stace, Alison Stace, Tucker Slingsby Ltd and Jennifer Warner
Designers:	Robert Mathias • Pedro Prá-Lopez, Kingfisher Design Services
Typesetting/DTP:	Frances Prá-Lopez, Kingfisher Design Services
Picture Research:	Kathy Lockley

The publishers would like to thank Joanna Hartleyat the Bridgeman Art Library
for her invaluable help.

Egyptian Art

The striking images of Egyptian art are a doorway into an otherwise closed civilization; providing an insight into the mind of a people far removed from that of any modern culture. A great deal of this art was created precisely so that the ancients would never truly 'die'. Monumental stone sculptures would allow pharaohs to stand before their subjects for ever. Deeply carved inscriptions would likewise tell of royal exploits for generations to come. Pharaonic tombs record the dangerous but always triumphant journey the kings made to join their fellow gods. Reliefs and paintings in non-royal tombs reveal people who revelled in life, and who so loved the land of Egypt itself that they used it as the model for a perfect afterlife.

There is a modern tendency to view ancient Egyptian thought and art as fixed throughout the whole of its history. A systematic study of Egypt's art, however, reveals numerous changes in form and approach, often mirroring shifts within society or the position of the state in relation to its neighbours. Some elements or techniques remain for substantial but finite periods of time. Others, such as the enduring pyramidal shape, show a significance beyond mere artistic device or convention. Occasionally a change will appear startling; the radical differences in the art of the Amarna period, for example, or the deliberate attempt to re-create the highly developed art forms of the Old and Middle Kingdom during the Saite period.

We are largely dependent on material and climate for the work that survives. Sculpture and sarcophagi of granite and other hard

stones are obvious long-lasting examples, as are wall paintings and wooden statues protected from light and air. Precious metals, though durable, were also desirable and few ancient Egyptian gold or silver objects have reached modern times. Most homes were of mud brick and have not lasted; the ordinary Egyptian was buried in a simple pit grave, perhaps with a small collection of grave goods. Household or cosmetic items have usually come down because they were included as grave goods or had been 'buried' in built-over or abandoned settlement sites.

Statues were usually reserved for gods, royalty and important personages. Several of the statues of pharaohs are life-size and have come from their mortuary temples - building complexes associated with the cult of the pharaoh after his death. Then there are the colossi, such as those of Ramesses II in front of the larger temple at Abu Simbel. Non-royal examples include the beautiful statues of Rahotep and his wife Nofret.

A number of tombs were cut out of solid rock and heavily decorated. In the Old Kingdom, stone walls were carved with reliefs; later, more roughly carved limestone walls were plastered over and then painted. Besides royal tombs there are others, mostly of courtiers, nobility or provincial officials; some belong to the artisans who built the royal tombs in the Valleys of the Kings and Queens. Some of their paintings and reliefs are on show in museums around the world; they depict games and banquets of the living, funerary preparations and ritual, and the idealized afterlife for which the tomb owners hoped. Because many of their paintings and inscriptions have lasted while those on less durable mud brick or wood have crumbled away, an impression has grown up of a people whose whole interest in life was death. This is simply an accident of circumstance.

These more prosperous Egyptians were buried with a number of things intended to facilitate their passage to the afterlife and to be of use when they reached it. Chief among these are the rolls of

papyrus inscribed with what are called Books of the Dead. These 'books' are in fact extensive lists of protective magic spells. They are accompanied by beautiful and elaborate illustrations that show the tomb owner undergoing the rituals that enable him to 'live' again. In addition, from the time of the Middle Kingdom coffins themselves were covered with spells and symbols. Mummies had numerous amulets enclosed within their linen wrappings; living Egyptians wore such amulets as charms for protection. A highly prized group of funerary items are the *ushabti* figures intended to carry out tasks for the deceased; some tombs contained dozens of *ushabtis*.

Finally, Egyptian art, language and writing are linked and hieroglyphs can be considered art forms in themselves. Some of the highly detailed glyphs from the Old and Middle Kingdoms were never surpassed.

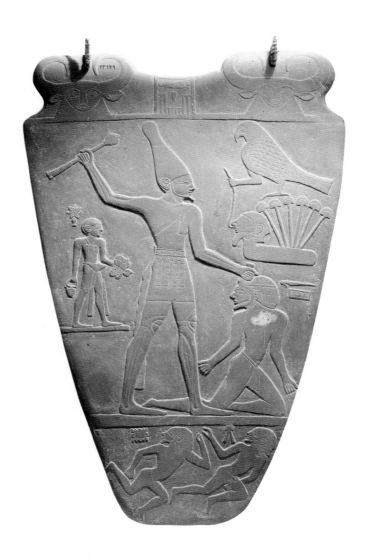

◁ ▷ **Narmer palette**
Hierakonpolis late Predynastic

Carved slate

PALETTES WERE SLABS OF STONE
used as grinding surfaces. Early in
Egyptian history, large
commemorative slate palettes
developed. They were intended
for display, often in temples. This
palette has details of the
unification of the Two Lands:
Upper Egypt, the valley in the
south, and Lower Egypt, the delta
area in the north. On one side a
king wearing the white crown of
Upper Egypt smites an enemy
with his mace. Below the ground
line are two dead foes. Above the
king, between two heads of the
goddess Hathor, is a square
containing the king's name:
Narmer. On the other side of the
palette the king, wearing the red
crown of Lower Egypt, walks in a
procession. The Narmer name
appears again above the image
and in front of the king's crown.
The two long-necked creatures
symbolize Upper and Lower
Egypt. The bull in the lowest
section represents the king
subduing another enemy.

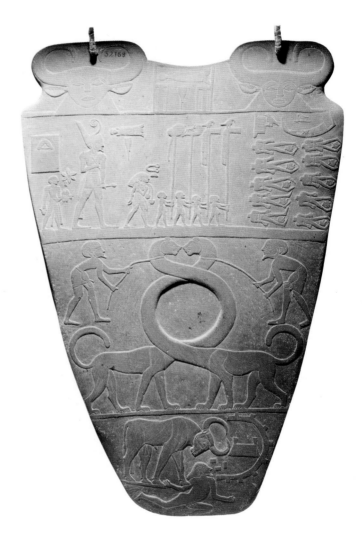

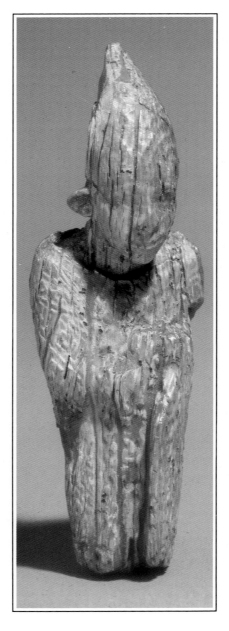

◁ **Figure of a king**
c1st Dynasty

Abydos Ivory

THIS SMALL 8.8 cm (3½ in) high
figure was found at Abydos. This
Upper Egyptian site was highly
significant around the time of the
unification of Egypt. Most of the
earliest pharaohs had tombs here.
This figurine wears the tall white
crown of Upper Egypt, and is
shrouded in the cloak worn by
kings during their jubilee, or *heb
sed*. This jubilee was a festival of
renewal held after a king had
ruled for several decades. During
the *heb sed* the king performed a
number of rituals, the best known
of which is a race. Pharaoh was a
living god. His function was to
maintain order (*ma'at*) so that the
gods would allow the Nile to flow
and its annual floods to bring the
fertile silt that enriched the soil.
If drought or famine or some
other disaster befell Egypt, it was
seen as the pharaoh's failure. The
heb sed was an important way of
reinforcing the power of a
long-ruling king.

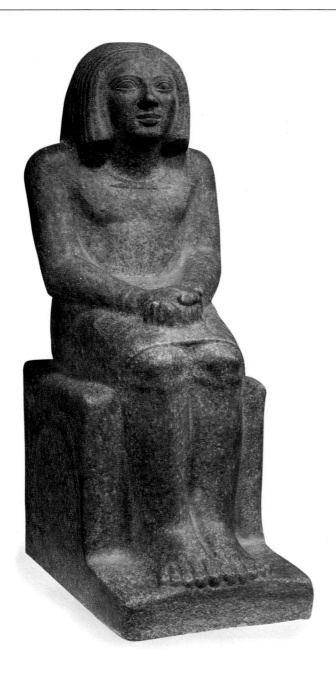

◁ **Statue of Ankh** 3rd Dynasty

Diorite

ANKH LIVED DURING the reign of the Pharaoh Djoser (Zoser), builder of the Step Pyramid at Saqqara. He must have been important to have had a statue of stone carved for him. This image of him on his rather cubic seat is a classic piece of Old Kingdom sculpture. The figure is heavy, the legs and feet ungainly. Interestingly, there is some modelling around his knees and chest. His short garment and perhaps some kind of collar or necklet and bands at his wrists are clear. But it is as if all the emphasis was to go into Ankh's serene, almost smiling face, which stands out in sharp contrast to the rest of the statue.

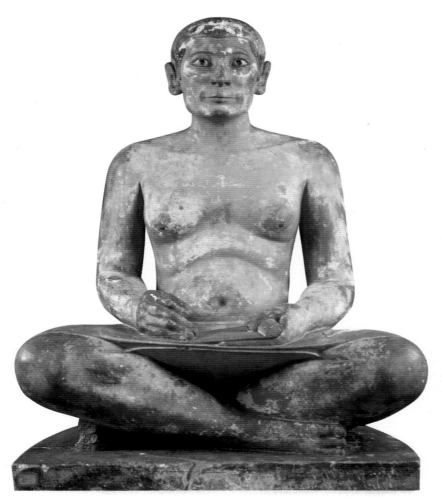

◁ **Scribe**
Saqqara Old Kingdom

Painted limestone

TO BE A SCRIBE in ancient Egypt
was to be one of the élite. Scribes
were educated in an otherwise
illiterate society. There is a long
Middle Kingdom text, known as
an Instruction, in which a father
journeys with his son to place him
in the scribal school. He discusses
the merits of all other possible
occupations – but none can
compare with the rewards his son
could reap if he applies himself to
his studies. Those in the highest
positions had statues made
showing themselves in the
traditional pose of the seated
scribe. This scribe sits proudly,
ready to write with his right hand
– the pen is now missing – while
unrolling papyrus with his left. His
head and torso are somewhat out
of proportion to his large crossed
legs, but otherwise the body is
quite lifelike and the inlaid eyes of
quartz, crystal and ebony
mesmerize the onlooker.

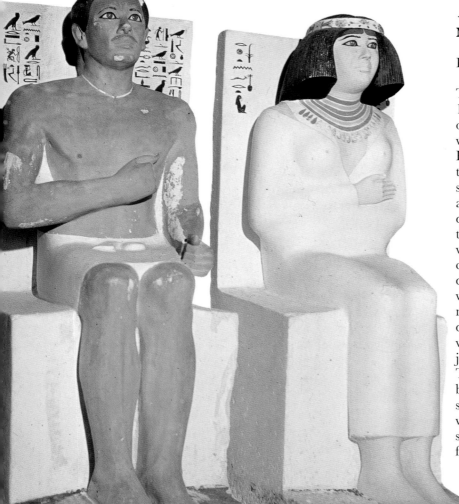

◁ **Rahotep and his wife Nofret** early 4th Dynasty

Painted limestone

THESE STATUES were found in 1871 in a tomb near the pyramid of Snefru at Meidum. Rahotep was a High Priest of Re at Heliopolis, and possibly a son of the pharaoh himself. Both his statue and that of his wife Nofret are finely preserved. Even the quartz and rock crystal inlay of their eyes is intact, something rare with Egyptian finds. According to convention, the man's skin is darker than the woman's. Rahotep wears a heart scarab around his neck, and Nofret's simple flowered diadem can be seen as an early version of the delicate gold jewellery of the Middle Kingdom. The formal postures of the figures bespeak their high position in society. It is said that the workmen who found these statues were so stunned by their realism that they fled in terror.

Detail

Head of Djedefre (Radjedef) Abu Roash 4th Dynasty

Red quartzite

THIS IS ONE of about 21 royal statues from the site of this pharaoh's pyramid. In this piece he wears the *nemes* headdress with a *uraeus*, or cobra. His face is carefully sculpted and the brow area over the eyes is effectively indicated, but not sculpted as it would be in statues of later rulers. The statue has traces of paint. (Much Egyptian sculpture and relief, including temple walls and columns, was painted. The paint has simply worn away.) Djedefre ruled for only about eight years between Khufu (Cheops) and Khephren (Khafre), builders of the two largest pyramids at Giza. Little is known of the reign of this king, but its shortness and the fact that he chose to place his burial complex away from that of Khufu at Giza may indicate some political problem.

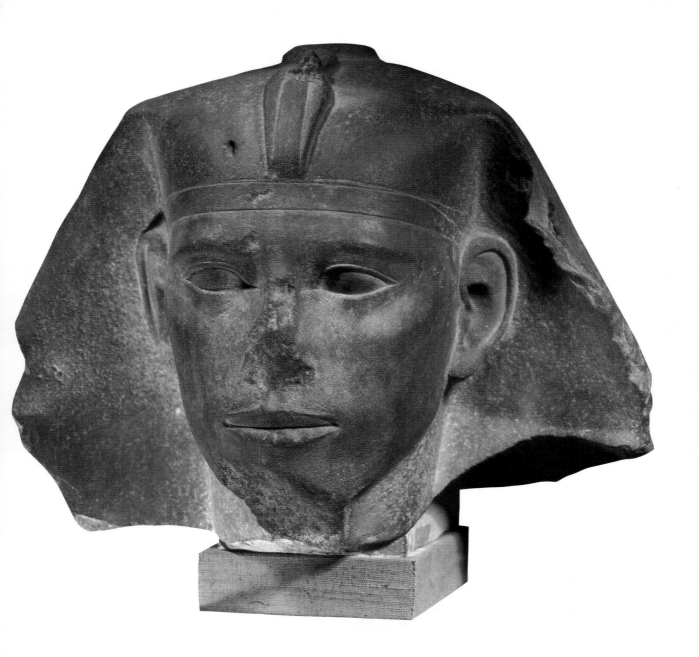

Detail

▷ **Stela of Princess Nefertiabet** Giza 4th Dynasty

Painted limestone

LIKE MOST ROYAL BURIALS of the Old Kingdom, the Great Pyramid of Khufu at Giza is surrounded by the tombs of his family and courtiers. These low, rectangular tombs with sloping sides are called *mastabas* from the Arabic word for bench, which they are thought to resemble. *Mastabas* can contain a number of rooms, some with detailed wall reliefs. Part of the decoration was a stela (a stone slab inscribed for commemorative purposes) with a depiction of the tomb owner, listing his or her name and titles, and showing a heavily laden offering table. *Stelae* were usually long and vertical. Shown here is a slab-stela, a style innovation during Khufu's reign – a stela that was wider than it was high. The king gave these to favoured courtiers. This belonged to Princess Nefertiabet, who wears the leopard-skin dress of a priestess. The slab-stela style lasted only a short time.

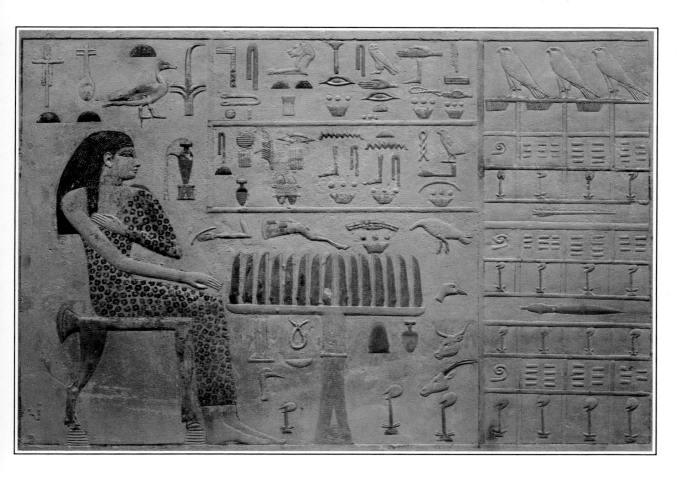

Detail

▷ **Dwarf Seneb and his family** Giza late 4th-early 5th Dynasty

Painted limestone

PORTRAITS OF DWARFS from ancient Egypt are not uncommon. Seneb held a high position at court and inscriptions in his tomb indicate that he was fairly wealthy. The names of Khufu and Djedefre appear on the statue base; Seneb was a 'servant of the god' to both rulers. Seneb's wife Senetites was a priestess of the goddesses Hathor and Neith. The couple's son and daughter are in the traditional pose for young children, naked, with side locks of hair and a finger raised to their mouths. Their position neatly balances the composition by filling the space usually occupied by the father's legs. Comparing this with the restrained statues of Rahotep and Nofret we can see that the artist was free of the strictures that applied to royal portraits and the whole composition is much more relaxed. A proud and smiling Senetites actually embraces her husband warmly.

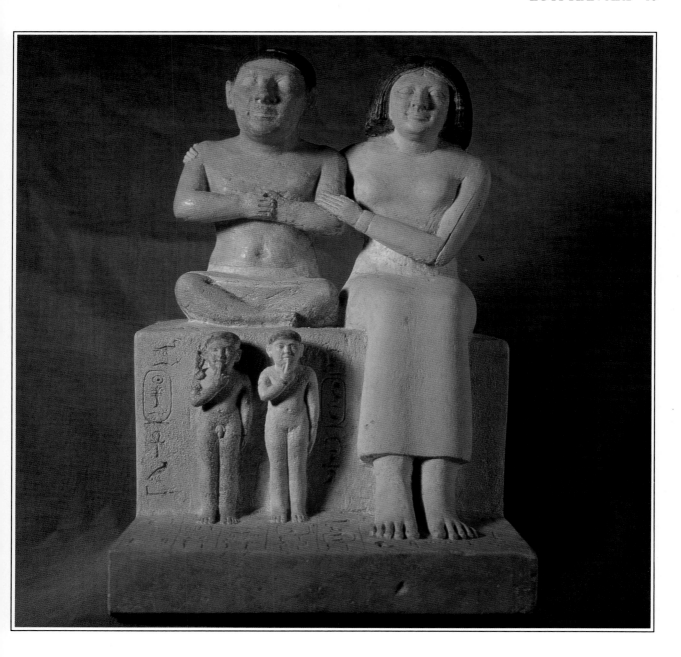

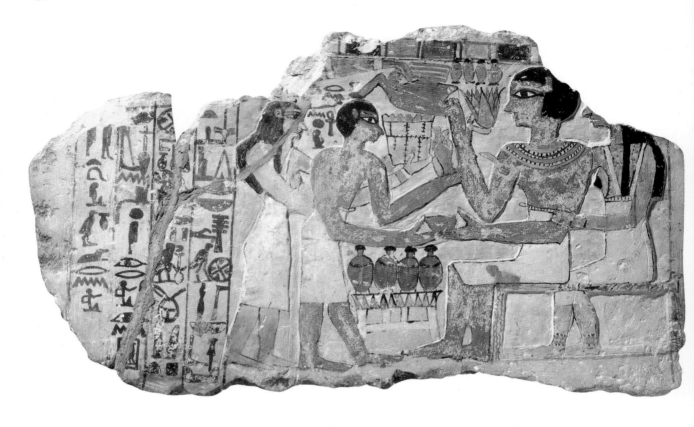

△ **Stela of Iri** 1st Intermediate Period

Painted limestone

THIS STELA IS FROM a time of great trouble. The royal family and the central goverment at Memphis became weak and local leaders usurped much power. There are hints of famine and possibly even cannibalism. The lack of direction in Egypt itself was obviously being felt in all aspects of society. What art has survived is of markedly poor quality, crudely drawn and, as with this example, luridly coloured. The carving here is shallow and uneven, and the human forms lack definition. Details such as fingers and toes are lost. Ears are badly placed, and eyes, mouths, noses and chins seem to bear no relation to one another. You have only to look at the right arm of the standing woman to see how impossibly long it is.

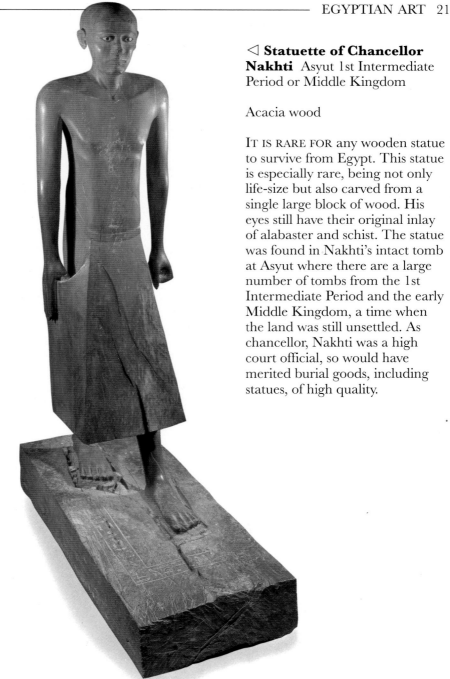

◁ **Statuette of Chancellor Nakhti** Asyut 1st Intermediate Period or Middle Kingdom

Acacia wood

IT IS RARE FOR any wooden statue to survive from Egypt. This statue is especially rare, being not only life-size but also carved from a single large block of wood. His eyes still have their original inlay of alabaster and schist. The statue was found in Nakhti's intact tomb at Asyut where there are a large number of tombs from the 1st Intermediate Period and the early Middle Kingdom, a time when the land was still unsettled. As chancellor, Nakhti was a high court official, so would have merited burial goods, including statues, of high quality.

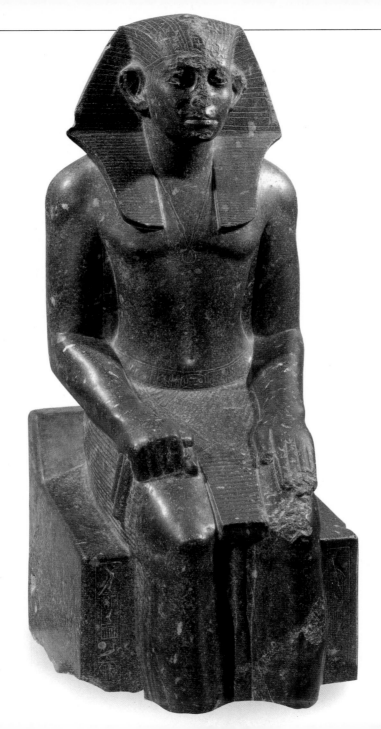

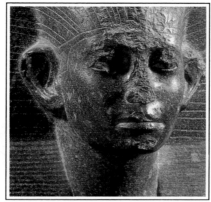

Detail

◁ **Sesostris (Senwosret) III as young man**
Medamud 12th Dynasty

Diorite

THE CHAOS OF the 1st Intermediate Period was followed by the Middle Kingdom during which Egypt was unified under a line of strong kings from Thebes. This was a time of peace and prosperity when literature and art flourished and pharaohs began to build large pyramid complexes again. Hieroglyphic inscriptions were arguably the finest ever produced. The portraiture of royal statues had a new realism. This figure of Sesostris III is from the temple of Montu at Medamud. This god was sacred in the Theban area and became a national god during this time. The impression given by this statue is that of a king, bearing the burden of leadership with the confidence of youth.

◁ **Sesostris (Senwosret) III as an old man**
Medamud 12th Dynasty

Diorite

SESOSTRIS ACCOMPLISHED much during his reign of approximately 35 years. With the recent history of the 1st Intermediate Period in mind, he reorganized the national administration so that he could suppress any potential rise of local power that threatened his rule. He fought in Nubia to the south, extending the boundaries of Egypt in the process. He also took his army into Palestine to the northeast. The Sesostris III we see in this fragment is a sobering contrast to the earlier statue. Here is a king who has ruled long and worked hard for his land and his people. The smooth lines of a full youthful face have been replaced by the careworn gaunt visage of a tired but still determined old man.

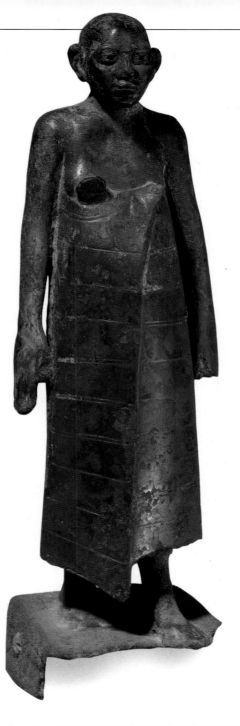

◁ **Statue of an official**
Middle Kingdom

Bronze and silver

THIS STATUE HAS BEEN DATED to
the reign of Amenemhat III. It is
of bronze, encrusted with silver.
Bronze is an unusual material and
this is one of its earliest such uses.
The long wrap-around garment
reaches to the chest of the
unnamed steward. It is safe to say
that the subject was an important
official, an assumption borne out
by his distinctive dress. The
deliberate impression of stoutness
is meant to convey that this man is
indeed successful and prosperous,
emphasized by the material used
for his statue.

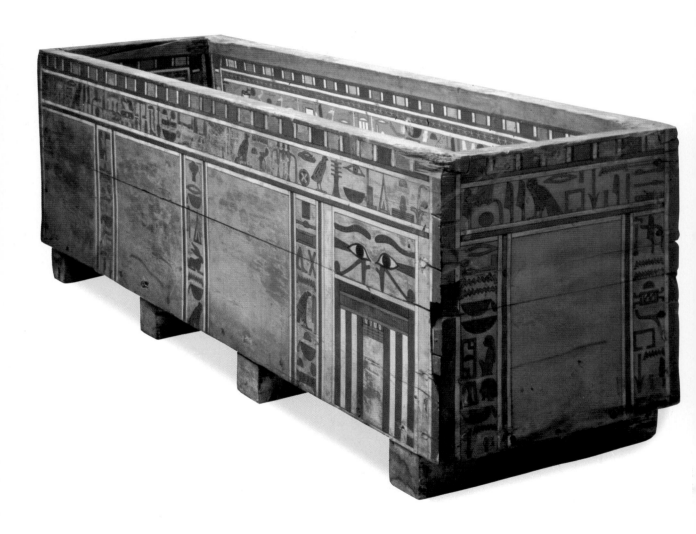

Detail

◁ **Coffin of the physician Seni** Deir El-Bersha Middle Kingdom

Bronze and silver

THE STYLE OF DECORATION, inside and out, make this instantly recognizable as a coffin of the Middle Kingdom. Seni's body would have been placed so that his face was 'looking through' the eyes of the god Horus, painted on the outside. The vertical inscription columns are derived from the spells of the Pyramid Texts carved on the tomb walls of the Old Kingdom pharaohs. The inscription was usually a standard offering prayer that included the name and titles of the tomb owner. Inscriptions inside the coffin are known as the Coffin Texts. These texts too are based on Old Kingdom spells and show that now even commoners – at least highborn or prosperous ones, such as Seni – had hopes of joining the gods in the afterlife.

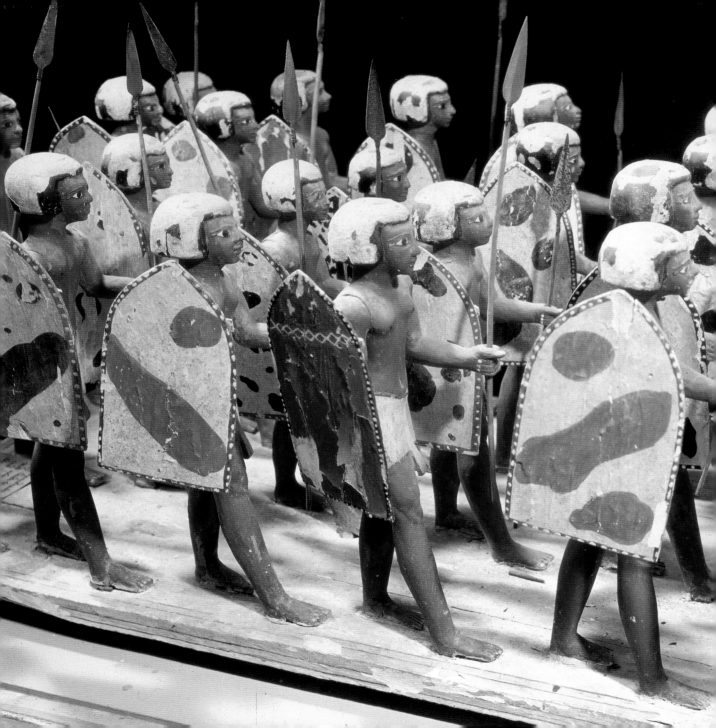

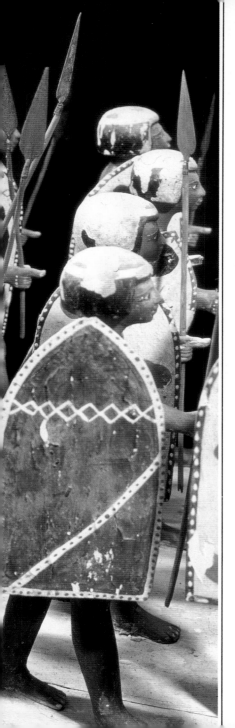

◁ **Tomb model** Asyut 11th Dynasty

Painted wood

TOMB MODELS ARE TYPICAL burial goods of the late First Intermediate Period and the Middle Kingdom and are often found on or near the painted wooden coffin. Many of the models are of everyday scenes and activities: homes with colonnaded courtyards and gardens, stables; baking, brewing and butchery; sailing and farming; weaving. The models give a very good picture of how some Egyptians lived. These model pikemen were found in the tomb of Mesehti, prince of Asyut.

It is fitting that such a leader should be buried with a model army. There is a companion piece containing 40 Nubian archers. The pikemen are native Egyptians, probably soldiers from the prince's own province. Note how the artist has varied the individual figures. Even the way some of the heads are slightly turned gives the impression of a marching unit frozen in time.

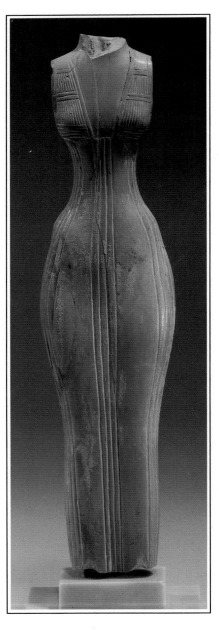

◁ **Female statuette**
Middle Kingdom

Ivory

This exquisite figure calls to mind the small predynastic female carving of early Naqada date. The bodice is of a type often seen on Middle Kingdom statues. The long, straight lines of the dress would appear to represent pleating, and the lined areas of the bodice are perhaps sections of gathered and stitched pleats. Like the changing statues of the pharaohs, this idealized female form is a far cry from the sturdy, chunky shapes of the Old Kingdom.

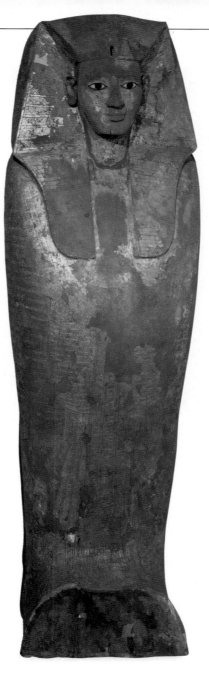

◁ **Coffin of King Nebkheperre Inyotef VII**
17th Dynasty Thebes late 2nd Intermediate Period

Wood and gilded gesso

FULL MAN-SHAPED COFFINS developed from the masks that covered the faces of early mummies. Such coffins had been used for several centuries before the appearance of this type in Thebes (modern Luxor) during the 17th Dynasty. It is large and rather crudely shaped. The coffin itself was hewn out of a solid log, then covered with plaster and painted. That of a commoner would have been finished in brilliant colours; that of a king was completely gilded. The body of the coffins were typically decorated with the wings of vultures. This has led to their being called *rishi* coffins, *rishi* meaning 'feathered' in Arabic.

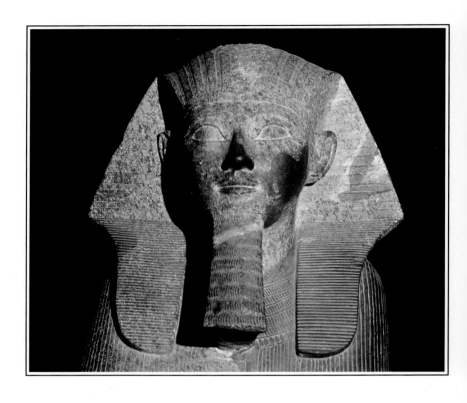

△ **Hatshepsut as sphinx** 18th Dynasty

Granite

HATSHEPSUT WAS THE DAUGHTER of Tuthmosis I and wife of her brother, Tuthmosis II, by whom she bore a daughter. His heir, Tuthmosis III, was a son by a minor wife, and succeeded to the throne as a child. Hatshepsut ruled as regent. After a short time she took the throne and declared herself pharaoh. For 20 years she ruled – not as queen, but as king. When Tuthmosis III finally came to power he attempted to destroy every monument his aunt had created. Her statues, her obelisks, her very name was to be wiped out. But enough of this remarkable woman's works have survived to keep her name – and her image – alive. Many of Hatshepsut's statues show her dressed as a male pharaoh, often bare-breasted with a short kilt, sometimes with the crowns of Upper and Lower Egypt. In this statue she is shown in pharaonic tradition as a sphinx, wearing the royal *nemes* headdress and beard.

▷ **Akhenaten** 18th Dynasty

Sandstone

ABOUT A CENTURY AFTER Hatshepsut's death, Egypt was shaken again, by a pharaoh who has been dubbed both visionary and heretic: Amenophis (Amenhotep) IV, husband of the beautiful Nefertiti and probable father of Tutankhamun. He suppressed the worship of the chief god Amun, and put in its place that of the Aten, a manifestation of the sun. In honour of his god he changed his name. The king moved his whole court to a new city built at the site of modern Tell El-Amarna, hence the 'Amarna period'. New images appeared in sculpture and relief. But the strongest image to emerge was that of Akhenaten himself – an elongated figure with full abdomen and hips, female yet not female, almost sexless. Some have speculated that the king had a disease that rendered him sterile, a theory questioned by the prominent display of 6 princesses.

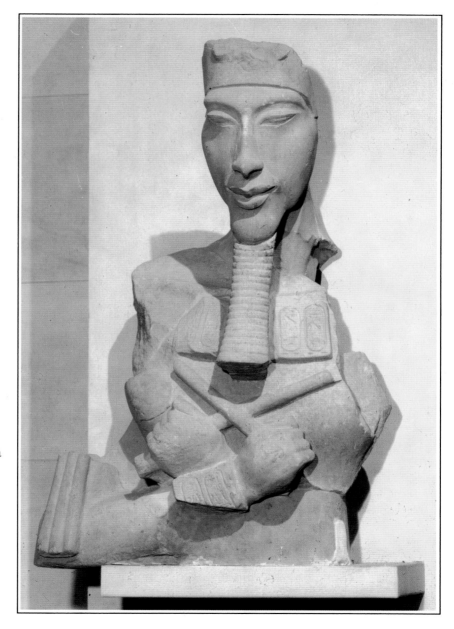

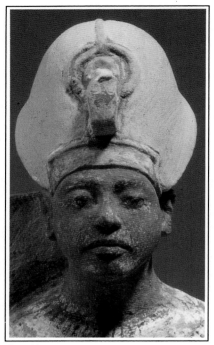

Detail

▷ **Statuette of Akhenaten and Nefertiti** Amarna 18th Dynasty

Painted limestone

DURING THE AMARNA PERIOD, the royal family itself became a focus of the Aten cult. The king and queen were depicted in affectionate poses with each other and their children, something unimaginable before this time. Perhaps they were seen as living representations of the god's bounty; certainly they would have been the chief link with the Aten.

This small statuette was part of a household shrine of an Amarna resident. Nefertiti's identity is clear from the crown, usually worn only by her; the figure of Akhenaten is more traditional, but the slight fullness of his lower torso hints at the Amarna school.

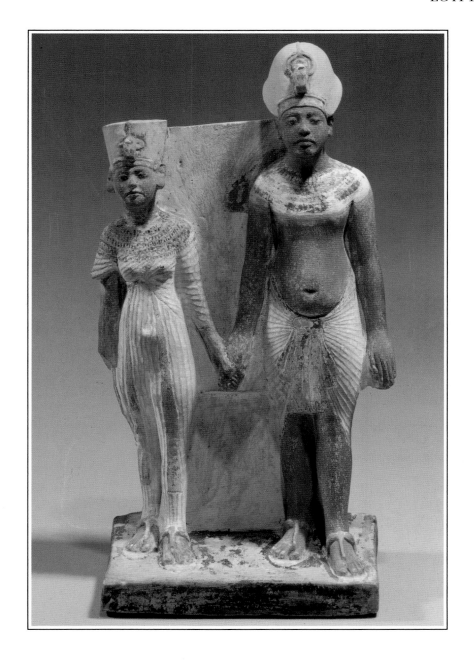

Detail

▷ **Mask of Tutankhamun**
18th Dynasty

Gold, lapis lazuli, carnelian, quartz, obsidian, turquoise and coloured glass

THIS MASK, REPRESENTING the Pharaoh Tutankhamun as the god Osiris, is undoubtedly the most famous ancient Egyptian object ever found. It is of sheet gold, over 54 cm (21¼in) high and weighs 11 kg (24lb). It lay over the face of the young king's mummy as it rested inside three massive coffins – the innermost of solid gold. Although it must be idealized, it is the clearest image we have of Tutankhamun's features. He wears the *nemes* headdress with the vulture (Nekhbet) and cobra (Wadjet), symbols of Upper and Lower Egypt. On his chin is fixed the artificial beard that denotes kingship. The broad collar necklace ends on each shoulder in a falcon's head, the falcon being the god Horus, son of Osiris, and the king being the living Horus. The mask was inscribed with a text from the Book of the Dead, calling upon the gods to protect the body of Tutankhamun.

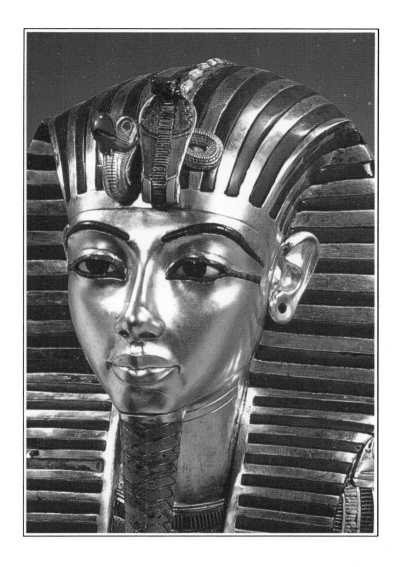

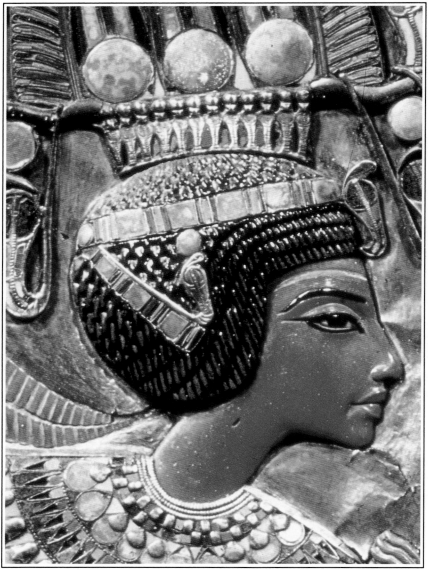

Detail

▷ **Throne back** 18th Dynasty

Wood inlaid with gold, silver, semiprecious stones, faience and coloured glass

THE CHAIR WAS ONE OF SIX from Tutankhamun's tomb, and is known as the Golden Throne. Its sloping back shows the king with his wife, Queen Akhesenamun, a daughter of Akhenaten and Nefertiti. It is as if the artist has captured an intimate moment for all time. Tutankhamun is in a relaxed pose and his queen almost appears to be smiling. It is impossible to imagine such a depiction of royalty without the influence of Amarna. The king's names appear in the oval cartouches (a shape probably originally based on a loop of twisted rope that encloses the chief royal names) behind him. Both his names and that of the queen (not shown) have been altered to end in 'amun'. It is probable that before this Tutankhamun read 'Tutankhaten', reflecting the heresy of the Amarna period that focused on worship of the Aten. By the time this Pharaoh died, the god Amun had been restored and the Aten was completely eclipsed.

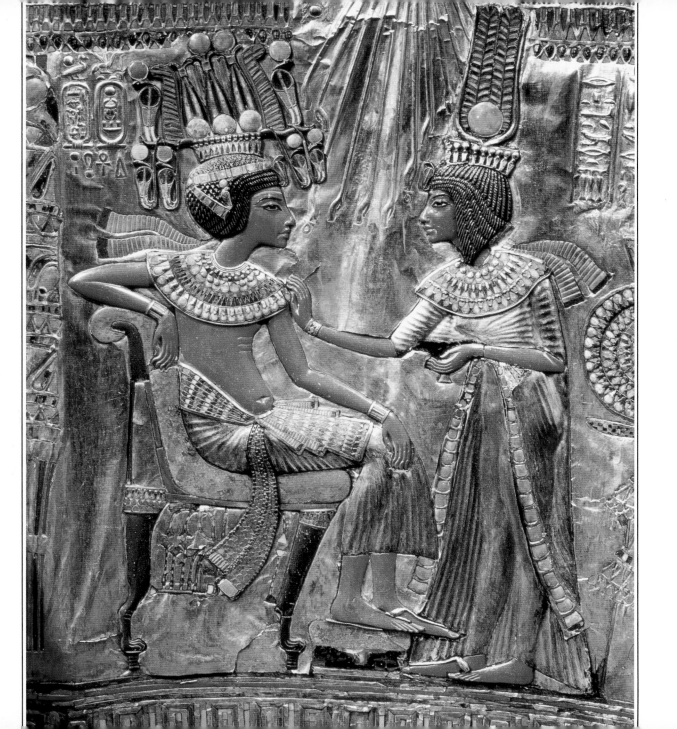

Detail

▷ **Pectoral of Tutankhamun** 18th Dynasty

Gold, inlaid with lapis lazuli, green felspar and calcite

THIS PECTORAL, OR PENDANT, is only 7.5 cm (3 in) high and 8.2 cm (3¼ in) wide. It is not only a beautiful piece of jewellery, it is also a clever play on the king's name. Pharaohs had a series of five names on becoming king, but two are most often used: the *nomen* (birth name) and the *prenomen* (adopted when taking the throne). Here the artist has taken the three hieroglyphic elements that spell out the king's *prenomen* – *Nebkheprure* – to create a single image. The small half circle at the bottom is the word *Neb*; the winged scarab beetle with three vertical lines that forms the main part of the piece is *khepru*; and the red disc surrounded by gold is *Re*, the sun god. *Nebkheprure* translates as 'the lordly manifestation of Re'.

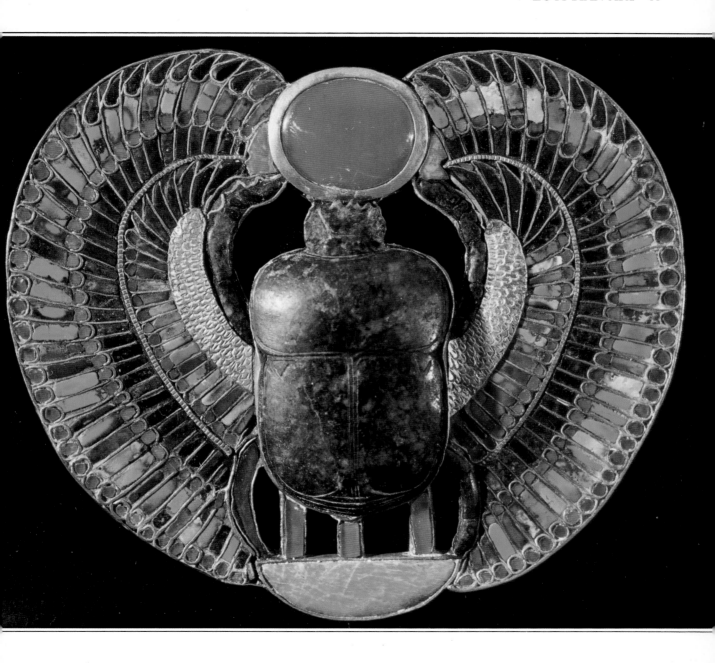

▷ **Painted cartouches from tomb of Horemheb**
Valley of the Kings 18th Dynasty

HOREMHEB WAS THE LAST PHARAOH of the 18th Dynasty. He was not royal, but rose through the army and took the throne after the death of Ay, successor of Tutankhamun. Like any other pharaoh, Horemheb adopted a complete set of royal names on his accession. In the oval cartouches are those by which he is best known: *Djeserkheprure-setepenre* and *Horemheb- meryamun* ('Holy are the Manifestations of Re-Chosen of Re' and 'Horus is in Jubilation-Beloved of Amun'). An Egyptian's name was important and if they were to live forever it must not be forgotten. Those who could afford an elaborate tomb had their name carved many times on its walls. To destroy all mention of a name was to rob its owner of immortality. With the survival of these beautifully carved and painted images, Horemheb rose to the highest level of all: he became one with the gods.

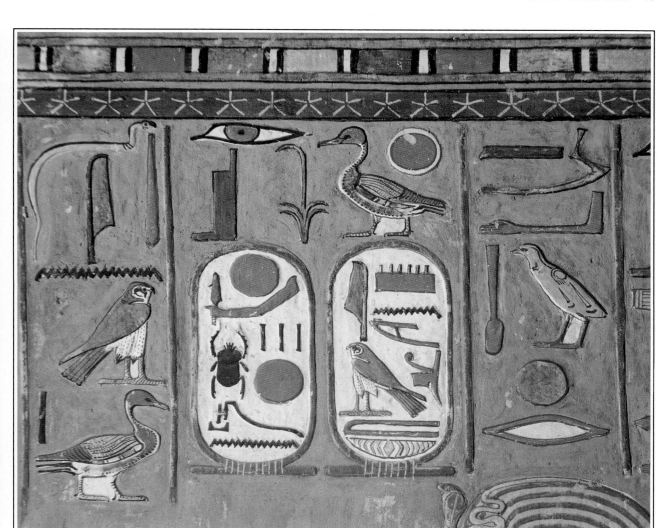

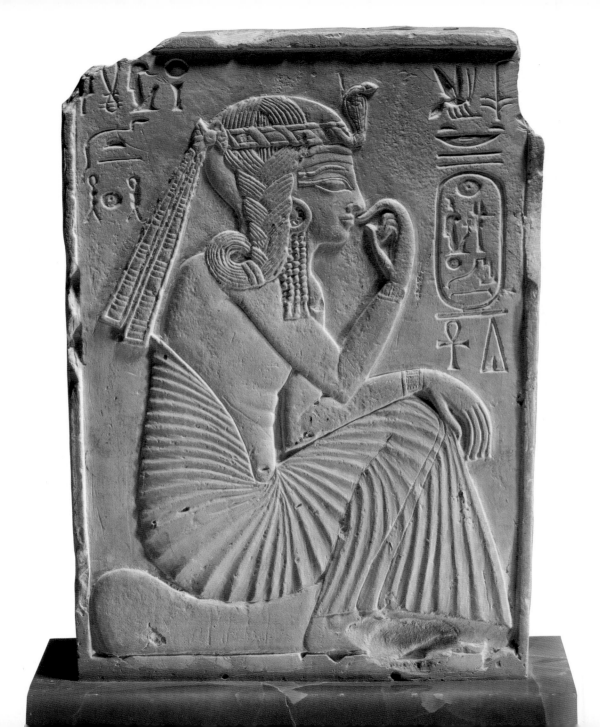

◁ **Relief of Ramesses II as a child** 19th Dynasty

Limestone

RAMESSES THE GREAT succeeded his father, the powerful Sety I, around 1290 BC, when in his mid-20s. This stela, or plaque, depicts Ramesses in the conventional pose of a child, his finger towards his mouth, and a plaited sidelock hanging over his shoulder. The fillet around his head carries the protective royal uraeus (sacred serpent) and his gown is finely pleated. 'Ramesses' was the king's birth name. The oval cartouche in front of him contains his formal prenomen: *Userma'atre'-setepenre'* ('Strong in Right is Re-Chosen of Re'). The hieroglyphs above the cartouche mean 'King of Upper and Lower Egypt, Lord of the Two Lands'.

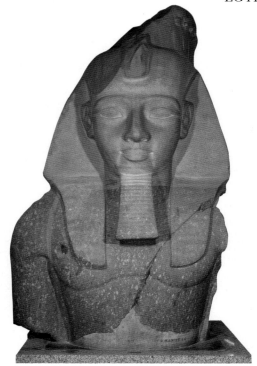

△ **Upper part of a colossus of Ramesses II** Thebes 19th Dynasty

Brown quartzite

RAMESSES THE GREAT was larger than life, even by pharaonic standards. He recorded details of his great battles on the walls of many temples – even when 'victory' was a distinct shading of the truth. He claimed to have 200 sons and as many daughters from what must have been an enormous harem. And he is one of the greatest builders in Egyptian history; what statues he did not commission himself, he usurped from previous pharaohs, carving his name over theirs. The image shown here is part of a colossus from the Ramesseum, Ramesses's great mortuary temple at Thebes. The stone was carefully chosen to simulate the appearance of eternal sunlight on the Pharaoh's face. The poet Shelley was inspired by news of Ramesses's colossi to write *Ozymandias*.

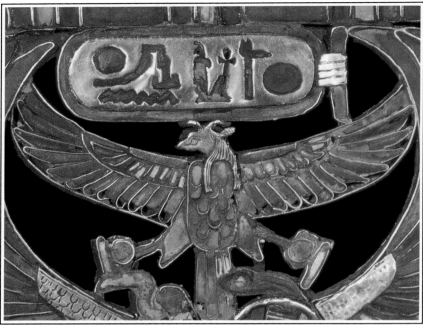

Detail

▷ **Pectoral of Ramesses II**
Saqqara 19th Dynasty

Glass-inlaid gold

THIS PECTORAL, OR PENDANT, is in the shape of a shrine, and was no doubt meant to have some magical, protective purpose. The large image is a version of a traditional funerary collar with the goddesses of Upper and Lower Egypt: Nekhbet (vulture) and Wadjet (cobra). A smaller winged god, with the head of a horned animal (thought to be a bull or a ram) raises the prenomen of Ramesses aloft. This god's talons hold *shen* signs – the symbol for infinity. The two tall symbols in the lower corners are *djed* pillars. The exact meaning of this ancient fetish is unknown, but it was powerful, and by this time was connected with Osiris, and thought of as his backbone.

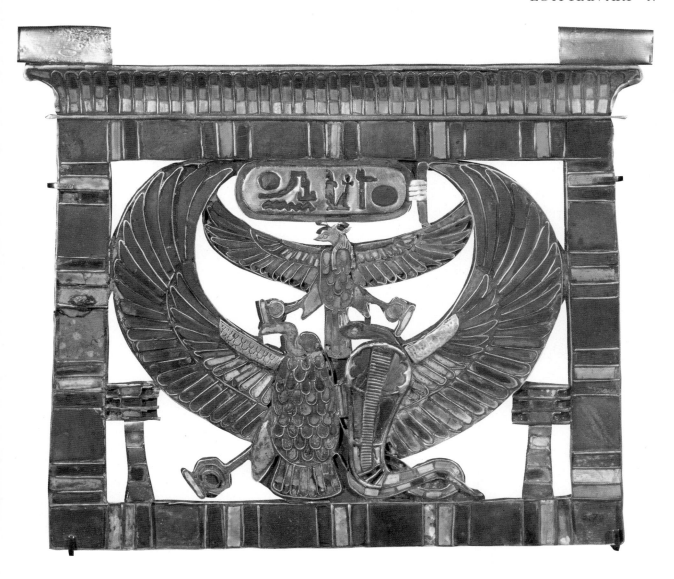

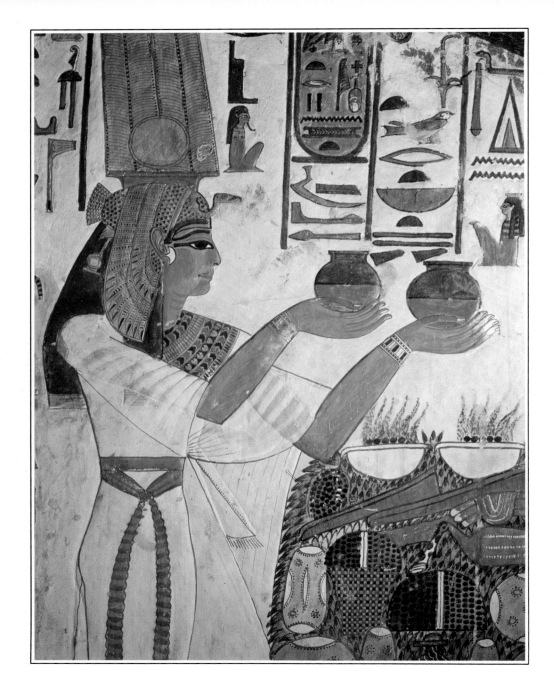

◁ **Queen Nefertari** Valley of the Queens 19th Dynasty

Wall painting

NEFERTARI WAS THE favourite wife of Ramesses II. She bore the king at least six children and probably died shortly after his 30th year on the throne. For her tomb the artists of ancient Egypt painted her not as a woman in middle age but as she must have looked when young. Her tomb, now restored, is perhaps the most beautiful of all to survive from ancient Egypt and contains many exquisite images of the queen. This painting is at the top of the sloping corridor leading to Nefertari's burial chamber. She wears a crown especially associated with her: the vulture headdress of the goddess Nekhbet, protector of Upper Egypt, surmounted by the sun disk and tall plumes. The oval cartouche in front of the queen's plumed headdress contains her name. Nefertari is presenting offerings to the goddesses Isis, Nephthys and Ma'at.

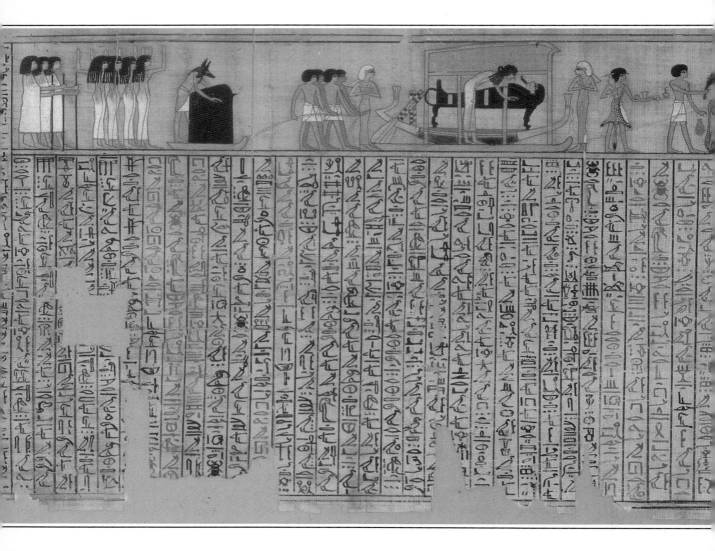

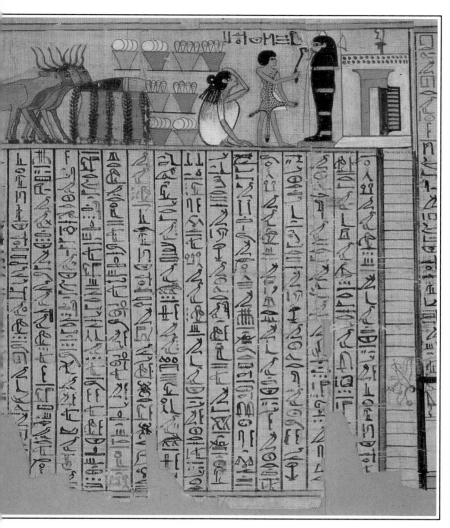

◁ **Book of the Dead of Nebqed** New Kingdom

BOOKS OF THE DEAD were rolls of papyrus that contained hymns and magical texts to guarantee safe passage to the afterlife. The text was illustrated. This one shows the funeral procession accompanying Nebqed's mummy. A female figure, possibly the widow, bends over the body on the bier. The figures either side of the barque probably symbolize the goddesses Isis and Nephthys, wife and sister of Osiris. The cattle and baskets of food are for the funeral banquet and possibly for offerings to be placed in the tomb. (Note the alternating use of light and dark colour to highlight figures of the men and cattle.) The most important part of the vignette shows the coffin upright before his tomb. A priest performs the magical Opening of the Mouth ritual that will allow Nebqed full use of his senses. The female figure crouches behind the priest in a traditional posture of mourning.

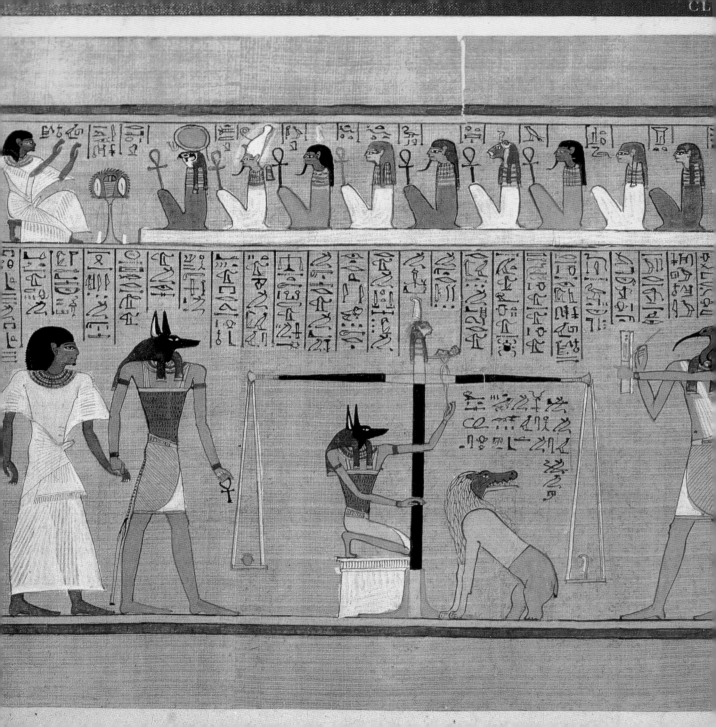

Book of the Dead of the scribe Hunefer 19th Dynasty

◁ *overleaf pages 52-53*

HUNEFER WAS AN IMPORTANT OFFICIAL under Sety I. His titles include Royal Scribe and Steward, Overseer of Royal Cattle and Scribe of Divine Offerings. His wealth and position are reflected in the quality of his funerary papyrus. Here Hunefer, dressed in fine linen, is led to the Hall of Judgment by the jackal-headed god Anubis. His heart is placed upon the scales and balanced against the feather of truth, symbol of the goddess Ma'at, whose figure tops the central post. The bizarre composite creature Ammit, the Devourer, waits hungrily for the ibis-headed god Thoth to record the result. If the heart weighs heavy, it is full of sin and deceit and Hunefer cannot enter the afterlife; such a heart would be the reward of Ammit. But the Devourer is to be disappointed, because the next scene shows Horus presenting Hunefer to Osiris, god of the underworld, and Isis and Nephthys who stand behind him.

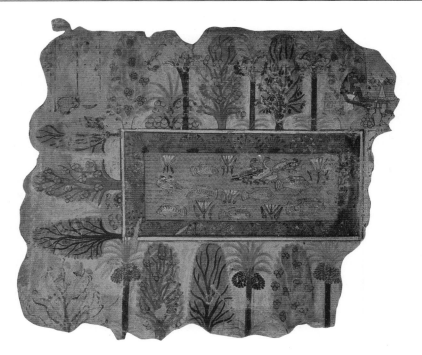

△ **Garden pool surrounded by trees**
tomb of Nebamun New Kingdom Thebes

Wall painting

NEBAMUN, 'SCRIBE AND COUNTER OF GRAIN', is thought to have lived during the reign of Amenophis III. The exact location of his tomb is unknown. Paintings from the tomb, however, can be seen as reflecting the life style he enjoyed while on earth, and that which he expected to enjoy in the afterlife. His garden pool has every kind of fish and fowl, and was made beautiful by delicate lotuses. Trees, lush and heavy with fruit, offer refreshing shade – an important consideration in the Egyptian heat. The goddess of the sycamore, a manifestation of the sky goddess Nut, is shown rising from the tree to the upper right. She is often seen like this in funerary papyri; it is her function to provide the deceased with air and water. The artist uses a peculiarly Egyptian perspective, viewing the scene from above, but with all the details straight on.

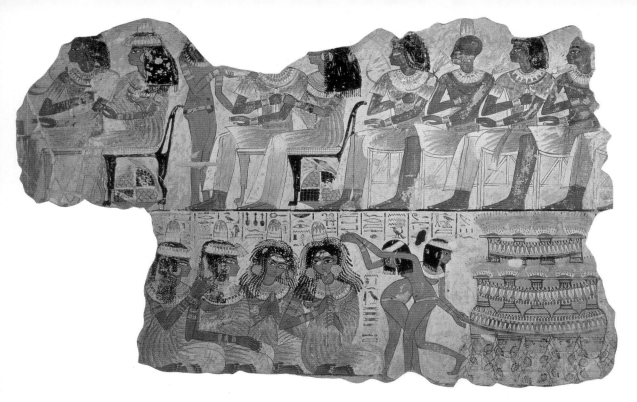

△ **Banquet scene** tomb of Nebamun Thebes New Kingdom

Wall painting

NEBAMUN OBVIOUSLY HAD great expectations for his social life. Here a number of well-dressed men and women are entertained at a lavish banquet. Servants wearing only jewellery provide food and wine, and musicians and dancers provide entertainment. Some guests wear wigs, and the clothing varies slightly, but all are dressed in the finest pleated linen through which you can see the outline of their slim bodies. Musicians and guests wear cones on their heads. These are thought to have been made of beeswax, containing a perfume that would melt through the evening and make a fragrant scent. Several of the guests hold lotus flowers, a symbol of love. The artist injects an element of animation with the expressions on the faces of the musicians, the first of whom appears to be clapping in time to the music. Most unusual are the full-face views of the musicians.

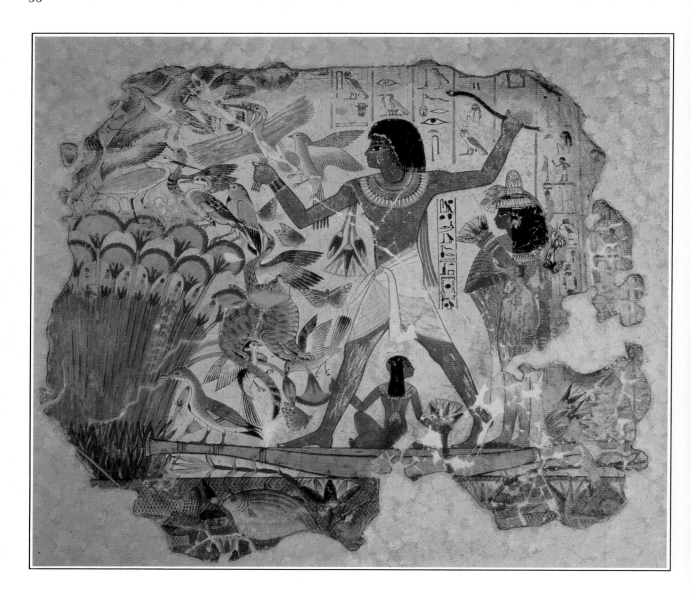

Detail

◁ **Hunting in the marshes** tomb of Nebamun Thebes New Kingdom

Wall painting

HUNTING AND FOWLING SCENES are often used in Egyptian tombs. Here Nebamun's wife stands behind him on the papyrus skiff and his young daughter sits beneath him. All three figures carry lotuses, and all are dressed in their finest clothes and jewels. The longer you look at the scene the more detail you see. Each of the animals is meticulously drawn, from the bird grasped by Nebamun's cat to the fragile butterfly hovering just above Nebamun's firmly fixed ankle. His strong figure dominates the composition and you can clearly feel the contrast between his powerful hunting skills and the panic of the fleeing birds. It has been suggested that all these creatures may symbolize spirits that Nebamun must defeat in the afterlife. A further sense of movement comes from the daughter who, with toes splayed, turns as if to speak to her mother.

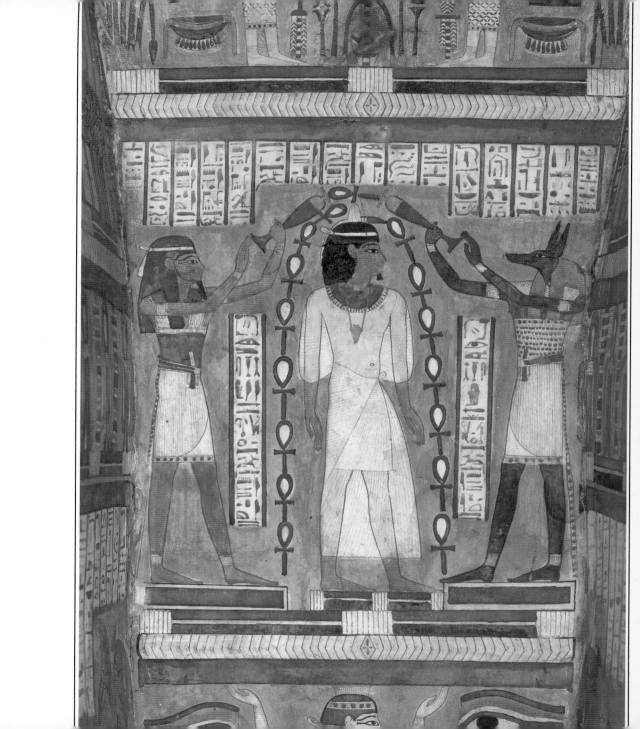

Detail

◁ **Detail of coffin interior of Amenimope**
late 18th-early 19th Dynasty

Painted wood

AT THIS PERIOD coffins continued to be man-shaped and painted, more emphasis being placed on the decoration of the inside of the coffin. In this example, seven painted panels run the length of the interior, featuring Osiris, Nephthys, Isis and other sacred inhabitants of the underworld. Shown here is a panel in which the deceased Amenimope stands in the centre, dressed in his finest linen with a perfumed cone upon his head and a heart scarab around his neck. A figure stands to either side of him (the jackal-headed god Anubis is to his left) and each pours what appears as a stream of *ankhs*, the hieroglyph for life. These form a protective arch around Amenimope.

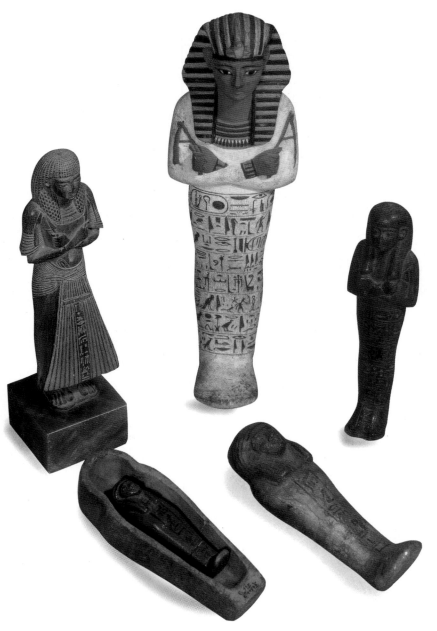

◁ **Funerary statuettes**
New Kingdom

IN THE AFTERLIFE the tomb owner
could be called on to perform
various duties, such as ploughing
the fields of eternity. Small figures,
called *ushabtis*, or *shabtis*, (also
shawabtis), were placed in the tomb
to substitute for the dead person
by magic. A wealthy Egyptian
would be buried with 365
ordinary *ushabtis*, one for each day
of the year. A number of overseers
were also included. From the time
of Amarna the overseer figures
began to be dressed in kilts; by the
end of the New Kingdom this was
common. Originally simple in
form, *ushabtis* came to be more
detailed, even having tools in their
hands and a carrying sack over
their backs. They were inscribed
with a chapter from the Book of
the Dead. They could be loose, in
a box, or sometimes in tiny coffins.
Ushabtis were in tombs of
commoners and royalty, and made
from a variety of material. This
group has examples of schist,
wood and faience. The largest is of
painted wood and belonged to
Ramesses IV of the 20th Dynasty.

▷ **Royal scribe Nebmerutef writing under the protection of Thoth as a baboon**
New Kingdom

Grey stone

THIS STATUE, and another in alabaster, were made as offerings to Thoth by Nebmerutef, chief lector priest during the reign of Amenophis III. The statues were probably presented at the god's temple at Hermopolis (modern El-Ashmunein). Thoth was the god of scribes, and the ibis and the baboon were animals sacred to him; he appears in both their forms. It is not surprising that so successful and ambitious a man should have chosen to make such an offering, for his pharaoh prized Thoth and had had a number of huge statues of the god in the form of a baboon placed in the sanctuary at Hermopolis.

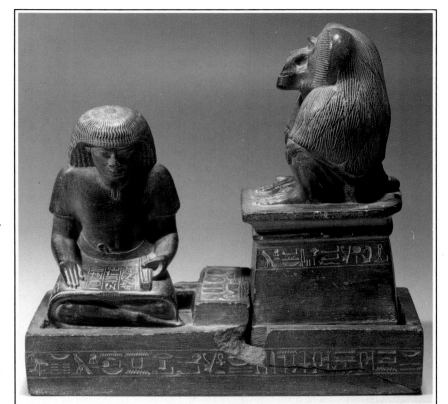

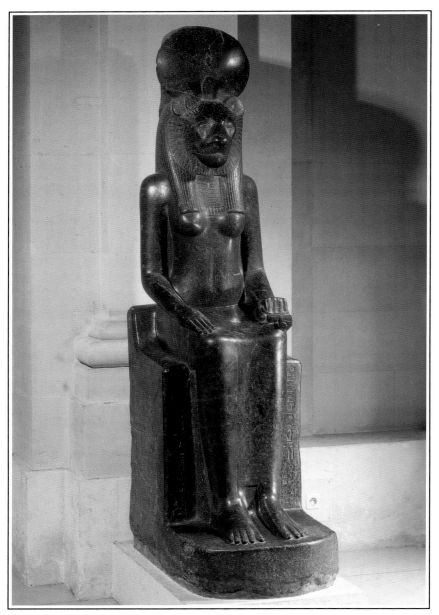

◁ **The goddess Sekhmet**
probably Thebes 18th Dynasty

Diorite

SEKHMET WAS A LION-HEADED GODDESS, whose name means 'powerful'. She was ferocious and connected with war, giving off such tremendous heat that the desert winds were held to be her breath. Like many deities, she merged with other, local, goddesses. In Thebes, for instance, she became identified with the goddess Mut. The mortuary temple of Amenophis III and the temple of Mut at Karnak held hundreds of statues of Sekhmet, some seated, some standing, always with a moon disc and holding an *ankh*, the hieroglyph meaning life. When standing she also holds a papyrus-shaped sceptre. Sometimes she wears a circular crown of raised cobras.

▷ **Relief of Hormin**
Saqqara 19th Dynasty

Limestone

THE INSCRIPTIONS ON TOMBS gave
details of the owner's life.
Parentage, achievements, titles
and position were all carefully –
and often boastfully – recorded for
posterity. For the Egyptian, these
carvings in stone guaranteed
immortality; for us they provide
invaluable details to flesh out
knowledge of the past. For
instance, Horemheb's earlier tomb
at Saqqara, before he became
Pharaoh, records his successes as a
general, and shows him receiving
honours from his king. The relief
shown here is similar and comes
from another Saqqara tomb
belonging to the official Hormin.
It is known as the 'stela of the
necklaces' and records his
receiving the Collar of Honour,
also known as the Gold of Valour,
from Sety I, who presents the
award from his Window of
Appearances.

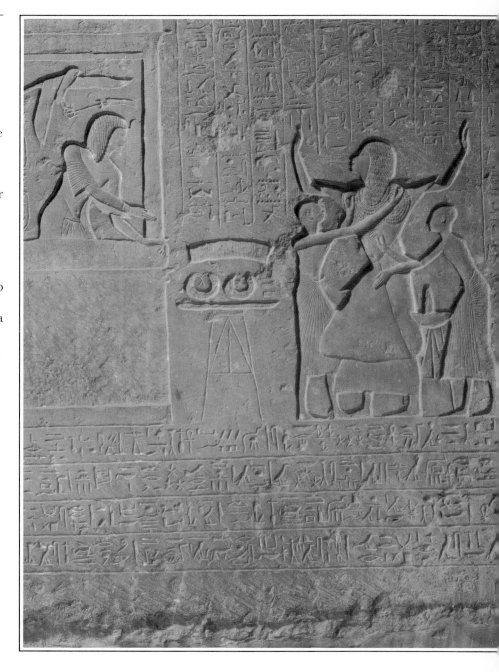

▷ **Servant girl carrying an unguent jar**
Thebes 18th Dynasty

Boxwood, gold and ivory

THIS DELIGHTFUL LITTLE FIGURE
was found in the tomb of
Meryptah, the last high priest of
Amun during the reign of
Amenophis III. Similar objects
have been found, but none is as
fine and lifelike as this one. Unlike
most figures in Egyptian sculpture
this girl is not rigid. Everything
about her suggests delicate
motion, coming forward to serve,
with the body carefully twisted to
balance the burden of the jar on
the left hip. While the torso and
legs (except for the toes) are not
overly detailed, the face is striking.
Her long, slightly slanted eyes,
painted in black and white, are
typical of the period. She wears
only a simple girdle of gold
around her hips and a necklace
with a pendant of the god Bes has
been painted around her throat.
The necklace ends in a delicate tie
that falls to the top of her shoulder
blades. A black plait coming from
the hole above the figure's left ear
has been removed.

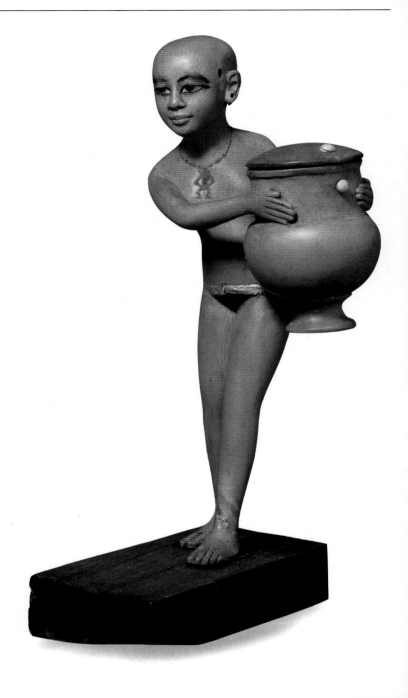

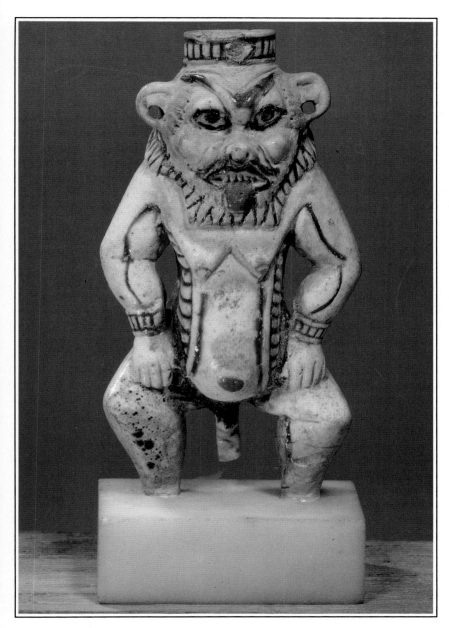

◁ **Kohl jar in the form of Bes** 18th Dynasty

Multicoloured faience

BES WAS A POPULAR DWARF GOD throughout much of Egyptian history. This example has been dated to the reign of Amenophis III or Akhenaten largely on grounds of its colours, a combination which rarely appears at any other time. The holes in the figure's ears were part of an arrangement to secure the jar lid. Although this is now missing, the jar still has the wooden stick used for applying the kohl to the eyes. Bes seems to have been connected with cosmetics generally, since he is on a number of similar kohl jars as well as cosmetic spoons. He seems to have signified good fortune and protection for the home, and has even been found on a frieze from the bedroom of Amenophis III. He is later a great protector of women in childbirth. Bes figures were common amulets.

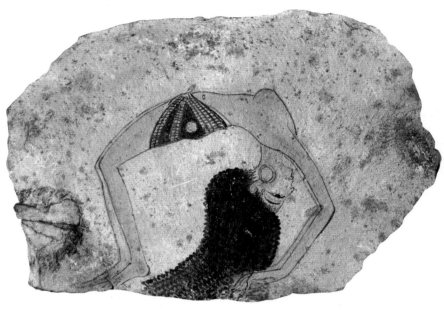

Gold and lapis lazuli

OSIRIS AND ISIS are brother and sister as well as husband and wife. Horus is their son, conceived by Isis, bringing life back to the dead body of Osiris through her great magical powers. Together they form one of the oldest and most sacred triads, or family groups, in Egyptian religion. This pendant is inscribed with the names of Osorkon II, one of a dynasty of kings of Libyan origin who took power when the previous family died out. The work is typical of the high standards achieved with metal during the Late Period. It is a traditional Egyptian subject, and shows an attempt to recall the finest art of the New Kingdom, but the figures are definitely Late Period. Their proportions and the modelling of the torso show a strong Libyan influence.

△ **Painted ostracon** 19th Dynasty

Limestone

ARTISTS OFTEN SKETCHED for their own amusement on pieces of broken pottery or limestone. Some are humorous and show animals engaged in human activities; others are caricatures of fellow Egyptians. Unlike most ostraca drawings, this one has also been coloured, and a great deal of small detail has been added: the individual tresses that form the rich mass of black hair, the cross-hatching on the dancer's loincloth to give an impression of some kind of geometrical motif. The earring adds an especially nice touch, although it seems odd that the hoop stayed in position through such an athletic movement. Some take this dancer's movements as evidence of foreign influences that appear to be softening the otherwise stiff and stylized Egyptian dances.

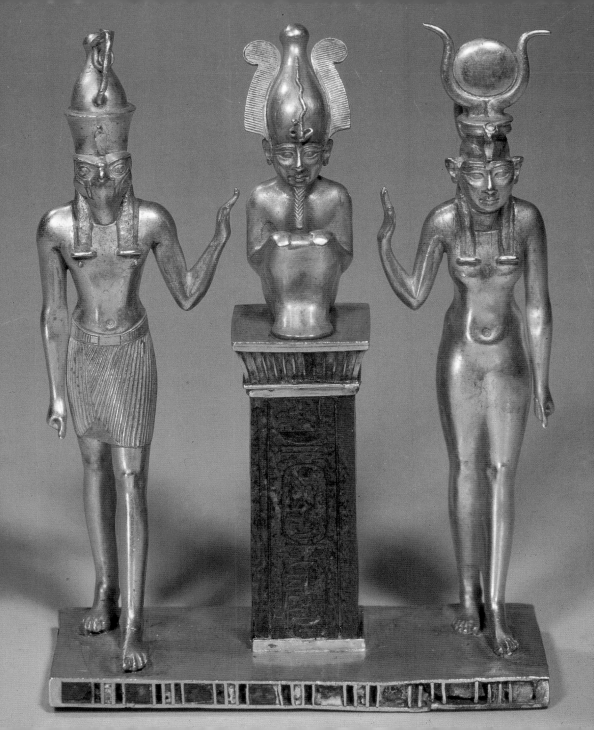

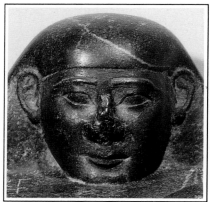

Detail

▷ **Block statues** 25th-26th Dynasty

Diorite

TRUE BLOCK STATUES began to appear in the Middle Kingdom. They show the subject sitting with knees raised to chest or chin level, and almost completely enveloped in a cloak. Feet and hands may be exposed. The block created was a convenient surface on which to inscribe the subject's names and titles. Such statues would have been created for high personages. One famous example is of Senmut, a high official under Hapshepsut, who was responsible for the education of the female Pharaoh's daughter. The head of the tiny princess emerges from the top of the cube shape, stressing her protection by the official behind her. These three block statues are from a time when there was a deliberate effort to recreate the best of earlier art forms, with a special emphasis on emulation of the Middle Kingdom.

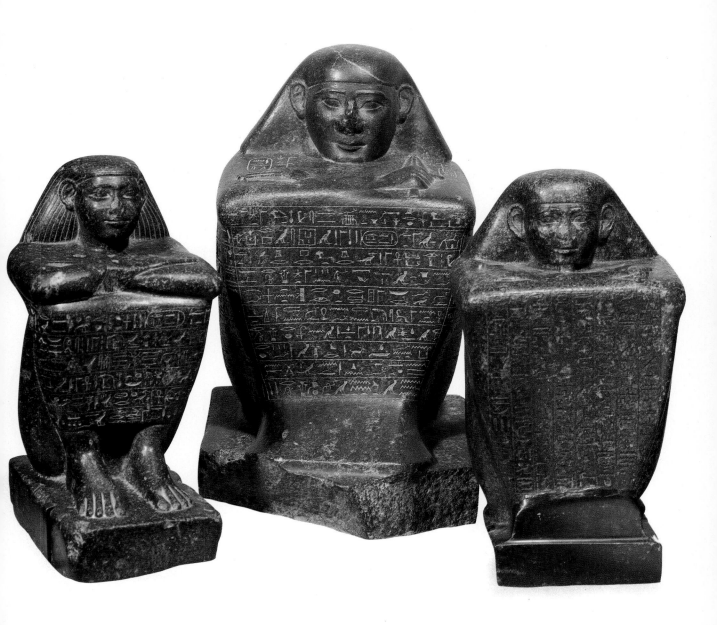

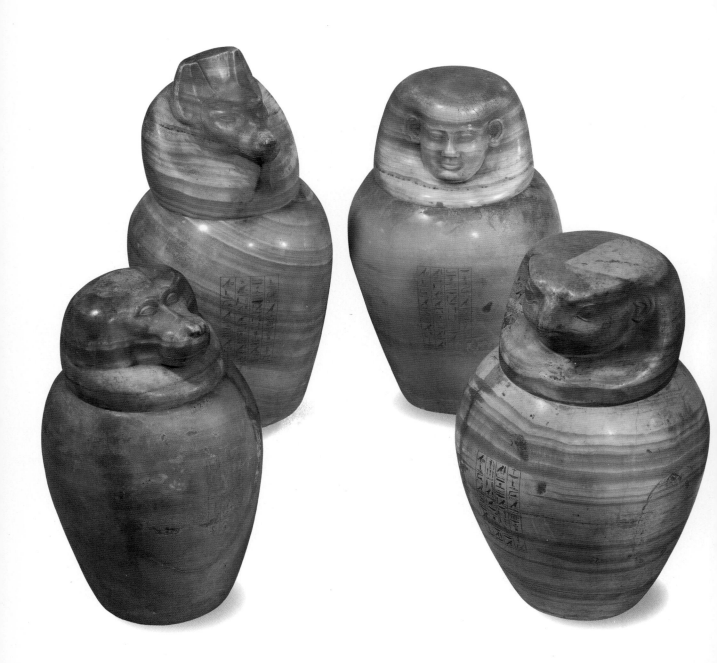

◁ **Canopic jars of Hor-ir-aa**
Late Period

Alabaster

WHEN A BODY WAS MUMMIFIED, the entrails were removed and treated separately. Only the heart was replaced in the chest cavity, because the Egyptians thought it was the seat of wisdom – the brain was scooped out and discarded. The remaining organs were placed in four lidded containers that were buried with the mummy. The jars take their name from the town of Canopus, near Alexandria, where Osiris was worshipped as a human-headed jar. Early versions of canopic jars had simple caps, while in some periods the lids had human heads. But in the finest examples each lid had a different head, representing the deity responsible for the organs within: the human-headed Imsety, the liver; baboon-headed Hapy, the lungs; jackal-headed Duamutef, the stomach; and falcon-headed Qebsenuef, the intestines. This beautiful example is a Late Period set, from a time known as the Saite Period, a time of high artistic attainment.

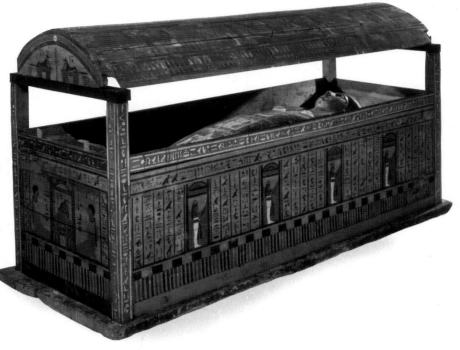

△ **Coffins of priest Hor** Deir el Bahri 26th Dynasty

ONLY ROYALTY and the very rich could afford to have a stone sarcophagus to hold their coffins. But a decorated wooden outer coffin served the same purpose. This particular style began in the 26th Dynasty. The inner coffin was made of cartonnage (layers of gummed linen and plaster), secured with lacing down the back, and painted with sacred images. The outer coffin was rectangular, with raised posts at the corners and a vaulted lid. It has been suggested that the shape of this coffin imitates that of religious shrines. (Note the painted shrines interspersed with text on the side of Hor's coffin.) The compartmentalized method of presentation and the carefully drawn hieroglyphic text call to mind the simple, but elegant painted coffins of the Middle Kingdom.

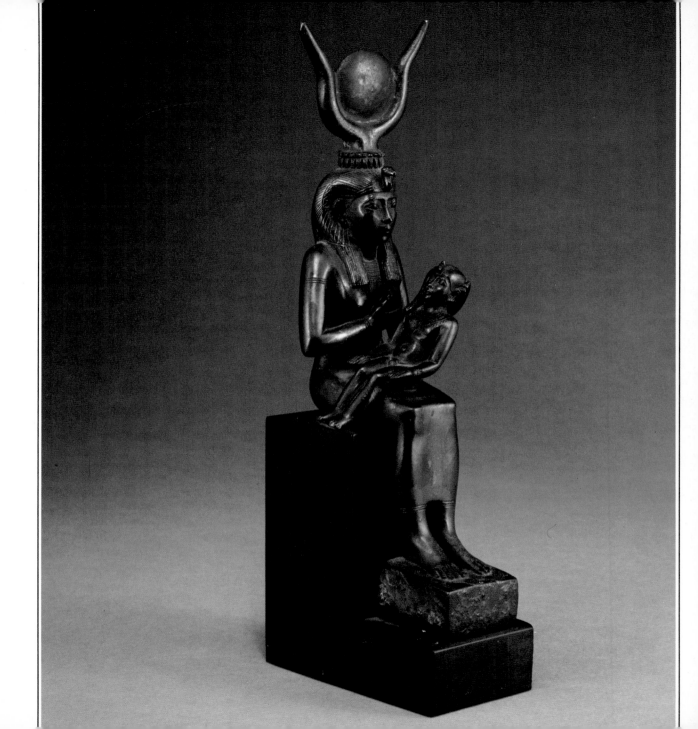

Detail

◁ **Isis and Horus** Late Period

Bronze

ISIS AS MOTHER is a powerfully
protective image. In her own right
she is 'great of magic'. As the
mother of Horus, she was also the
'mother' of pharaoh, the living
Horus. As Isis nurtures the infant
Horus, so she is nurturing pharaoh
and, through him, Egypt itself.
During the New Kingdom she
began to merge with the goddess
Hathor, hence that goddess's
attributes of cow's horns and sun
disc. The symbol of Isis was a high,
cubic throne, a sort of L-shape
with a high or thick base piece, so
this image of her seated calls to
mind that symbol and reinforces
the identity of the statue.

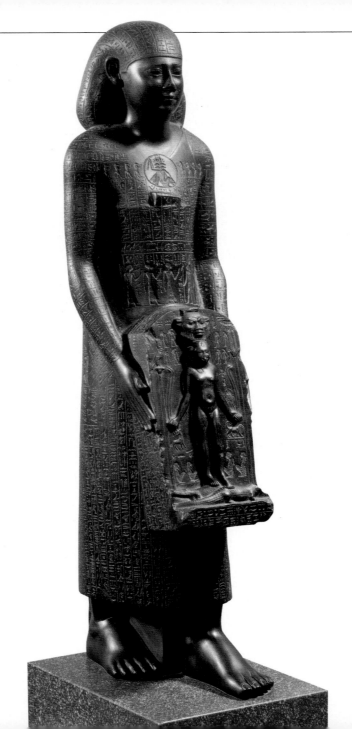

◁ **Statue with magical texts for healing** 30th Dynasty or early Ptolemaic Period

Basalt

THE EGYPTIANS HAD highly developed medical skills. They even successfully used procedures such as trepanning, where a section of skull is removed to relieve pressure on the brain. People also came to the temples where priests interpreted their dreams by referring to standard texts on dream symbolism. (Freud was fascinated by this and collected and studied the ancient dream records.) This statue is of a priest holding a *cippus*, or stela, of Horus. On it the child god clutches snakes, lions and scorpions; the god Bes is over his head and crocodiles beneath his feet. The statue itself is covered with magical formulas, and simply by drinking water poured over it, a 'patient' could be cured. Stelae like this, sometimes in bronze, were often set up in public places. Drinking the water poured over them gave protection against reptiles, or could heal stings or bites.

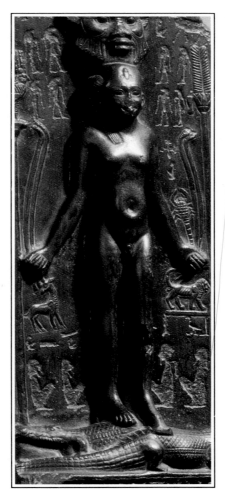

Detail

Detail

▷ **Cult statue of Osiris** Ptolemaic

Gilded wood with bronze

NATIVE EGYPTIAN RELIGIOUS practices continued to flourish under the Ptolemies. The cults of Osiris and his sister/wife Isis were especially prominent. The rocky island of Biga near the island of Philae in Upper Egypt had long been thought of as the burial place of Osiris. During the Ptolemaic Period Philae became a major cult centre for the worship of Isis. The massive Isis temple and a number of smaller structures built by this Greek dynasty can still be seen today. This statue is of the god Osiris, in his usual mummiform shape, and wearing the *atef* crown. Some think that this image was actually used in temple ritual; the survival of such sacred statues is rare.

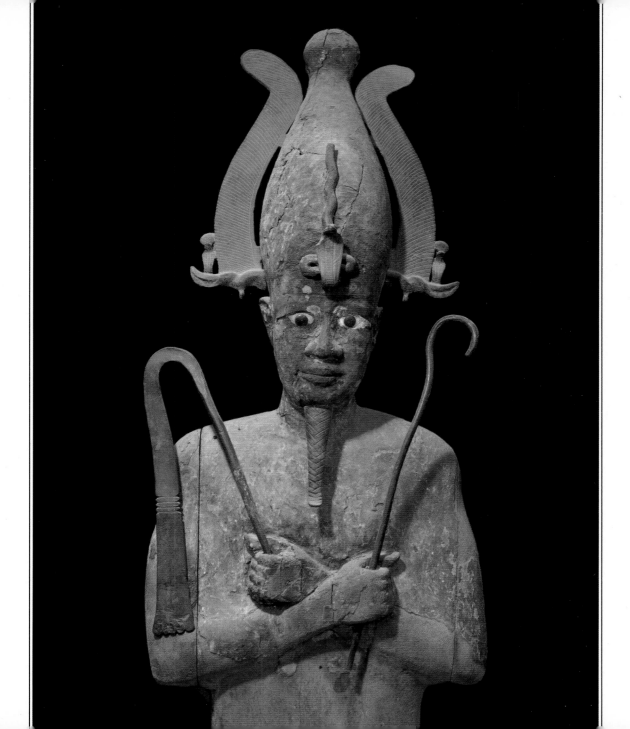

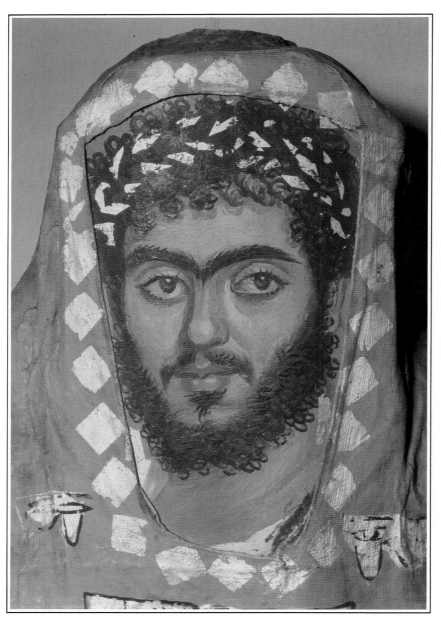

◁ **Encaustic portrait detail of the mummy of a young man** 2nd-3rd century AD

GRAECO-ROMAN SETTLERS continued the practice of mummification, painting the linen bandages with Egyptian-derived motifs. But they added their own techniques of naturalistic portraiture. Replacing the old cartonnage mask was an idealized portrait on thin wooden board, set within the painted bandages. These portraits were first found at Saqqara (near Cairo) in the early 17th century, but two massive finds in the Faiyum area in the 19th century have led to all such works being called 'Faiyum portraits'. This portrait was found at El-Hibeh, in Middle Egypt. The startlingly lifelike quality of the portraits is the result of a method using beeswax as a medium for the coarse natural pigments, hence the term 'encaustic'. The technical aspects – purity of the wax and the possible uses of heat – are still debated, but the effect was a long-lasting work, whose appearance resembles a modern oil painting.

ACKNOWLEDGEMENTS

The publisher would like to thank the following for their kind permission to reproduce the paintings in this book:

Bridgeman Art Library, London/**Egyptian National Museum/Giraudon:** 8, 9, 28-29; /**Egyptian National Museum:** 13, 19, 32, 36, 37, 38, 39, 40, 41; /**British Museum:** 10, 26, 27, 31, 45, 52-53, 54, 55, 56, 57, 71; /**Louvre, Paris:** 11, 12, *14, 15, 16, 17,* 20, 21, 22, 23, 24, 25, 30, 33, 34, 35, 44, 50-51, 60, 61, 62, 63, 65, 67, 68, 69, *70, 74, 75;* /**Louvre, Paris/Lauros-Giraudon:** *46, 47;* /**Louvre, Paris/Giraudon:** *58, 59, 76, 77;* /**Tomb of Horemheb, Thebes, Egypt/Giraudon:** *42, 43;* /**Valley of the Queens, Thebes, Egypt**/Giraudon: 48 (*also used on front cover, back cover detail and half-title page detail*), *49;* /**Oriental Museum, Durham University:** 64; /**Freud Museum, London:** 72, 73; /**Fitzwilliam Museum, University of Cambridge:** 78; /**Egyptian Museum, Turin:** 72

NB: Numbers shown in italics indicate a picture detail.

Every effort has been made to trace the copyright holders and we apologise in advance for any unintentional omissions. We would be pleased to insert the appropriate acknowledgement in any subsequent edition of this publication.

◁ **Statue with magical texts for healing** 30th Dynasty or early Ptolemaic Period

Basalt

THE EGYPTIANS HAD highly developed medical skills. They even successfully used procedures such as trepanning, where a section of skull is removed to relieve pressure on the brain. People also came to the temples where priests interpreted their dreams by referring to standard texts on dream symbolism. (Freud was fascinated by this and collected and studied the ancient dream records.) This statue is of a priest holding a *cippus*, or stela, of Horus. On it the child god clutches snakes, lions and scorpions; the god Bes is over his head and crocodiles beneath his feet. The statue itself is covered with magical formulas, and simply by drinking water poured over it, a 'patient' could be cured. Stelae like this, sometimes in bronze, were often set up in public places. Drinking the water poured over them gave protection against reptiles, or could heal stings or bites.

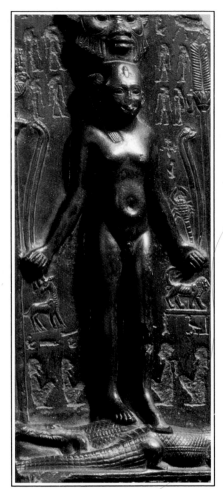

Detail

Detail

▷ **Cult statue of Osiris** Ptolemaic

Gilded wood with bronze

NATIVE EGYPTIAN RELIGIOUS practices continued to flourish under the Ptolemies. The cults of Osiris and his sister/wife Isis were especially prominent. The rocky island of Biga near the island of Philae in Upper Egypt had long been thought of as the burial place of Osiris. During the Ptolemaic Period Philae became a major cult centre for the worship of Isis. The massive Isis temple and a number of smaller structures built by this Greek dynasty can still be seen today. This statue is of the god Osiris, in his usual mummiform shape, and wearing the *atef* crown. Some think that this image was actually used in temple ritual; the survival of such sacred statues is rare.